# CITY
# CATS

## EDITED BY J. C. SUARÈS

CollinsPublishersSanFrancisco

*A Division of* HarperCollins*Publishers*

First published 1994 by Collins Publishers San Francisco
Copyright © 1994 J. C. Suarès
Captions copyright © 1994 Jane R. Martin
Additional copyright information page 80

Library of Congress Cataloging-in-Publication Data

City cats / edited by J. C. Suarès.
p. cm.
ISBN 0-00-255251-5
1. Photography of cats. 2. Cats—Pictorial works.
I. Suarès, Jean-Claude.
TR729.C3C57 1993
779' .32—dc20          93-31566
CIP
Printed in Italy
2 4 6 8 10 9 7 5 3 1

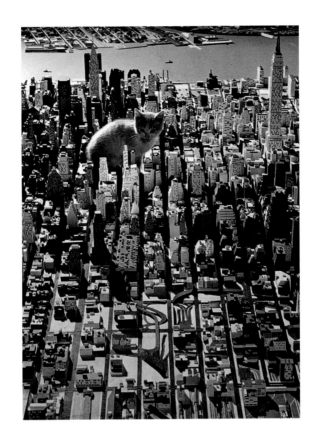

ALFRED GESCHEIDT
*Cat on Manhattan*
New York, 1964
"Before the set of Manhattan was lugged to the
1964 World's Fair, I went out to the builder's studio in
Thornwood, Westchester. I wanted to show the model's scale,
so I rented a cat with a trainer and brought them with me.
The set was solid. We walked around it barefoot.
The cat seemed fascinated, but he sat very still."

The toughest cat I've ever known was born in a cardboard box on a rainy fall day in an empty lot between brownstones on New York's West Side. The small black and white mother raised her litter of two males and two females as well as she could. She raided trash cans and killed mice but often went hungry as city cats do in cities everywhere.

From my window across the street I watched the kittens grow up and learn to fend for themselves. When someone placed rat poison nearby and they got into it, all but Cat (I never gave her a name) died. I took her home, barely alive. As she recovered we became friends.

By the time she was six months old she seemed like an ordinary little cat: gray and white and very clean. She had an unusually large appetite, however, and ate everything from cat food to leftovers. She chewed right through porkchop bones and ate ham, bread, and french fries and loved to lick the bottoms of omelet pans.

The first demonstration of her toughness came during her seventh month. A friend visited with his Great Dane. It was assumed that the cat would hide at the sight of a two-hundred pound dog but nothing of the kind happened. Instead Cat systematically jumped onto the kitchen table, from the kitchen table to the top of the refrigerator, and from the top of the refrigerator to the back of the dog. She sunk her claws into the back of his neck and bit his head. With the dog howling in pain it took two people to remove her.

When spring came, Cat took to wandering down the fire escape and wreaking havoc in the adjoining backyards. Neighborhood cats kept away under the threat of violence, dogs were equally intimidated and the cops were called more than once on their behalf by outraged neighbors.

Cat's biggest test came when a friend who owned a bar on West 86th Street, and who had heard me brag about Cat's take-no-

prisoner policy, asked to borrow her for a few days to get rid of his mice. She would spend three days down in the basement and hopefully clean the place up. I promised to visit her every evening around midnight.

The first day I got a glorious report: Cat had killed, dismembered, or disabled a dozen mice and a rat. The tally was just as impressive the second day: more death, more maiming. But on the third day, as I was just getting ready to go fetch Cat, I got a distress call from my gin mill friend.

I couldn't believe my eyes when I got to the bar. There had been a serious brawl—several busted chairs, a broken table, a smashed mirror and dozens of broken bottles and glasses. My friend stood in the middle of the wreckage, dumbfounded.

It seemed that Cat had discovered a leaky keg of beer and had gotten schnockered in the cellar. At some point she'd come upstairs

and discovered that someone had snuck a German Shepherd into the bar. A ten-minute brawl ensued, resulting in the dog and its owner beating a retreat onto 86th Street, and several hundred dollars' worth of damage.

I found Cat in the basement, sleeping it off. She was sleeping on her back with one eye towards the door. At close inspection she bore no bruises, but still had German Shepherd hair in her mouth.

Cat and I moved to the country shortly after that. There, she quickly developed a reputation as a feline Attila the Hun. No dog, cat, raccoon, crow, or snake was too tough for her to tackle. When neighbors confessed awe at her toughness I explained that she was a real city cat, raised on the streets of New York, the toughest kind there is.

*J. C. Suarès*

YLLA
*Tico-Tico Encounters a Cat*
New York, c. 1950
From the series on Tico-Tico the squirrel,
taken at Ylla's West 57th Street studio.

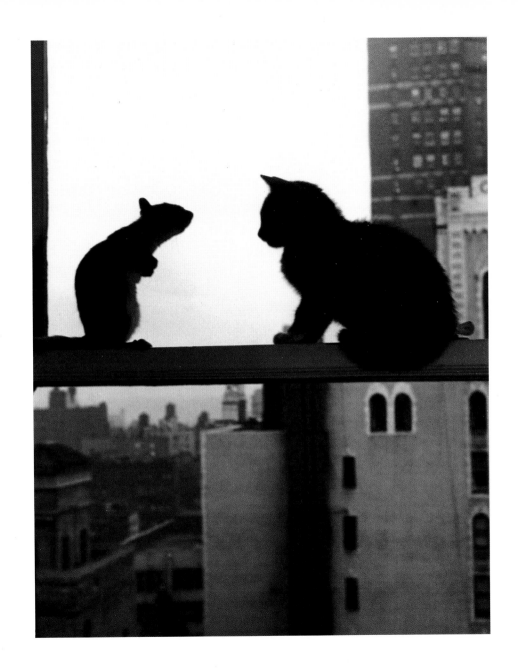

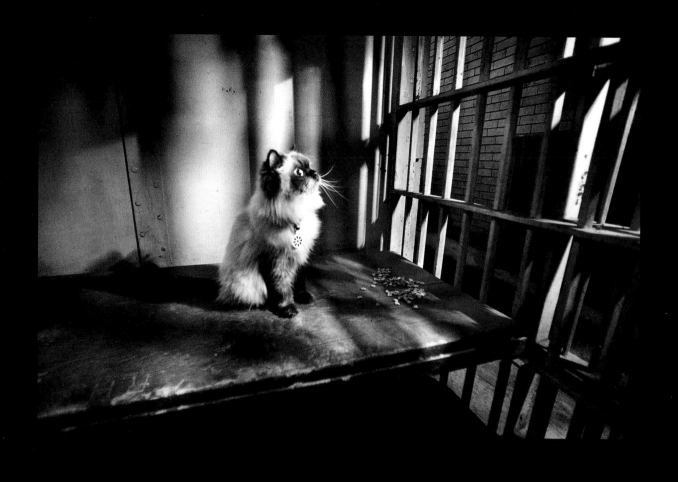

TERRY DEROY GRUBER
*Maggie*, from the *Working Cats* Series
Pittsburgh, Pennsylvania, 1979
"This is Maggie, a second-generation penitentiary cat. An inmate
told me that her mother was the best ratter he'd ever seen."

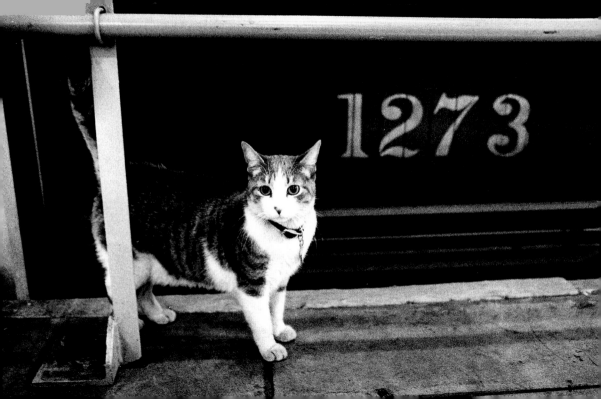

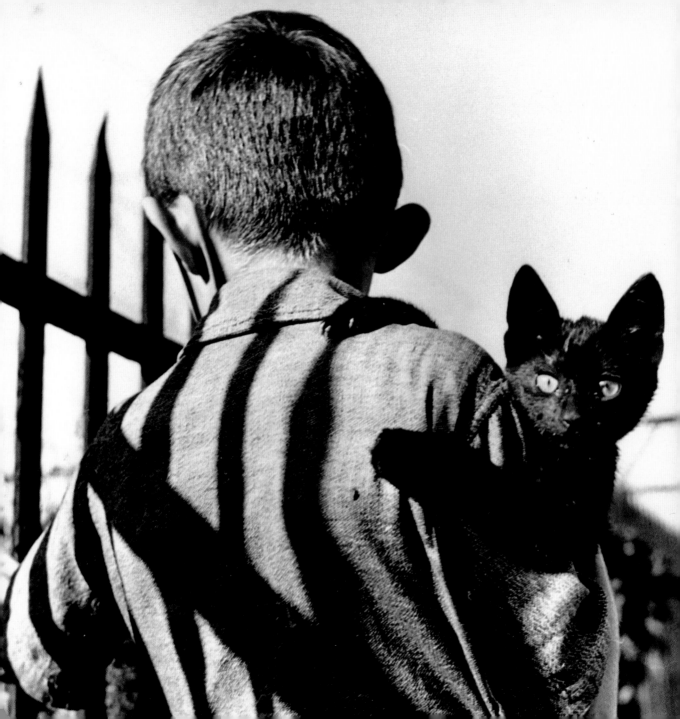

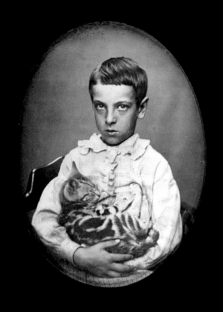

SILAS HOLMES
*Portrait of a Boy with Cat*
New York, 1850
Holmes had a studio at 289 Broadway from 1850–1852,
where he made many well-posed daguerreotypes of people
and their pets, usually dogs, who were used to leaving the house.
Far less common was the customer who brought in a cat.

*Opposite:*
JOHN FRANK KEITH
*Untitled*
Philadelphia, 1920
One of countless portraits the photographer made
of people on their front stoops.

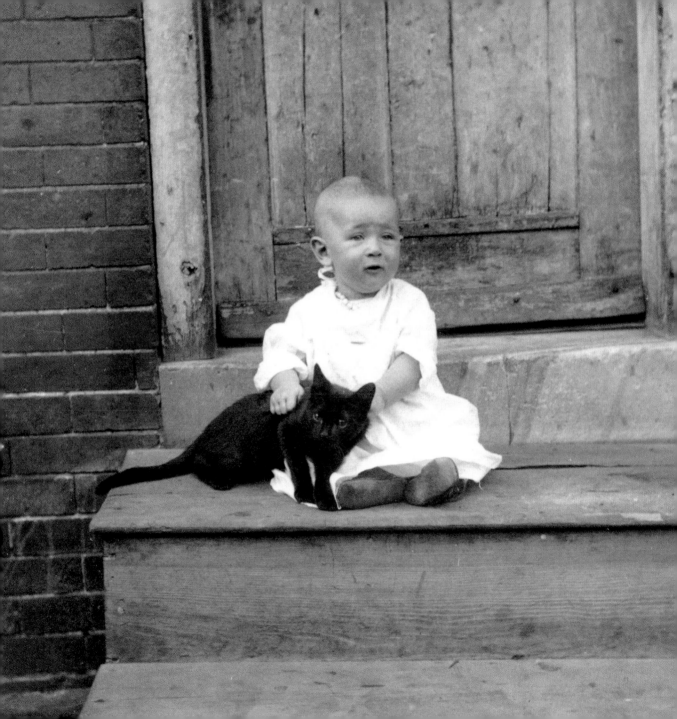

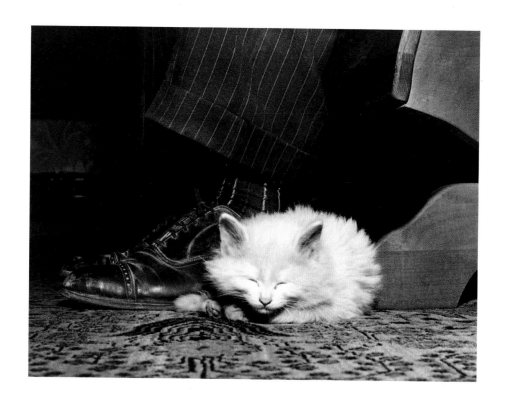

WALTER CARLOCK
*Untitled*
Ramsey, New Jersey, 1940

*Opposite:*
WALTER CHANDOHA
*Paula Chandoha and Our Kitten Smiling*
Long Island, New York, 1956
"The kitten was called Smiling for obvious reasons.
He was about eight weeks old here, the little mayor
of our city of daughters and cats."

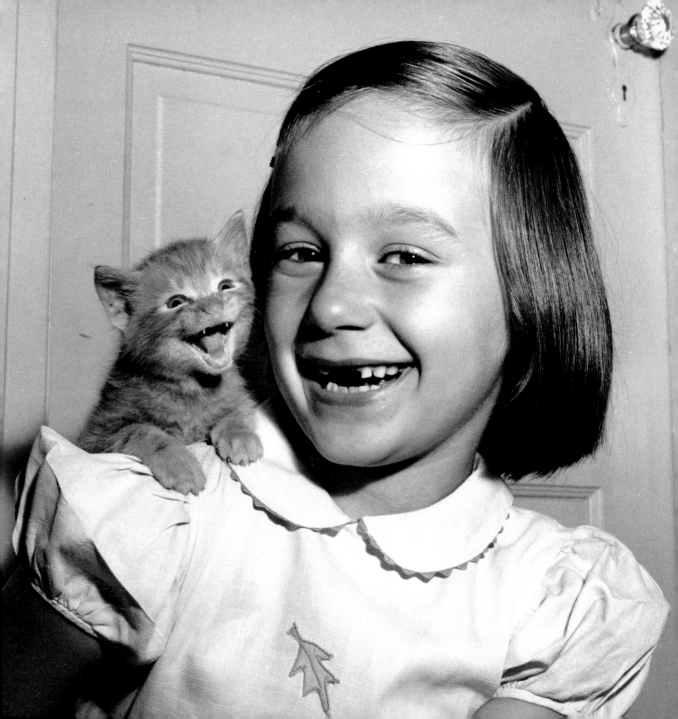

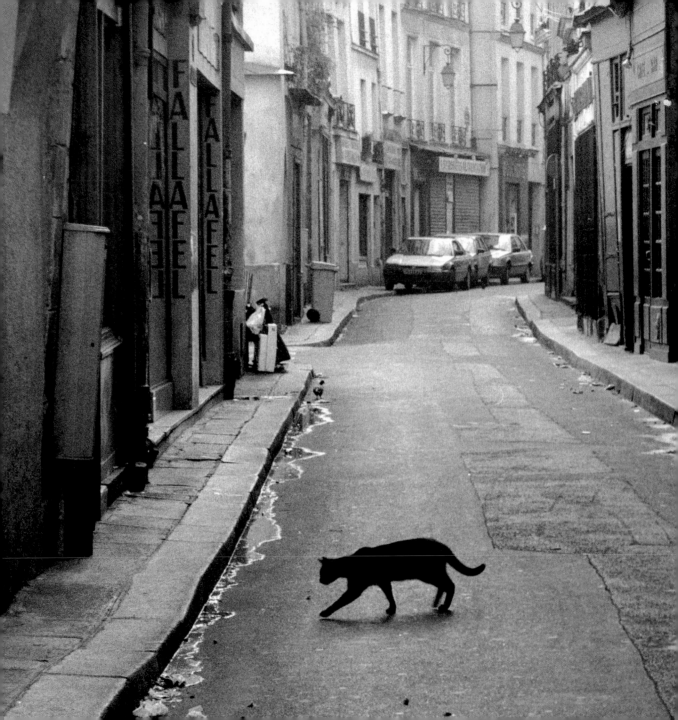

Marvin W. Schwartz
*Crossing the Street in the 4th*
Paris, 1986
"One Sunday morning I happened to notice
this cat crossing the rue du Rosiers in the Marais.
Usually nobody notices street cats,
who are completely different from domestic ones.
They live day to day and are the best fighters
in the world, but most of the time they're invisible.
The Marais was a very poor area before gentrification.
Now the cat lives in a housing project."

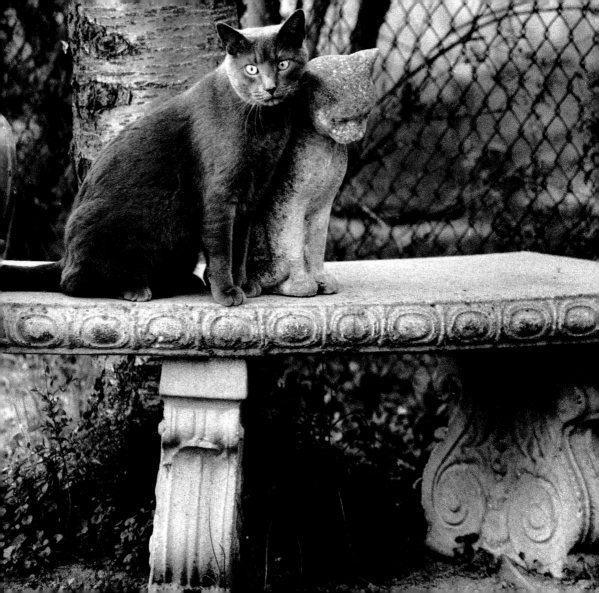

Ylla
*Alley Cats at Dinner*
New York, c. 1950

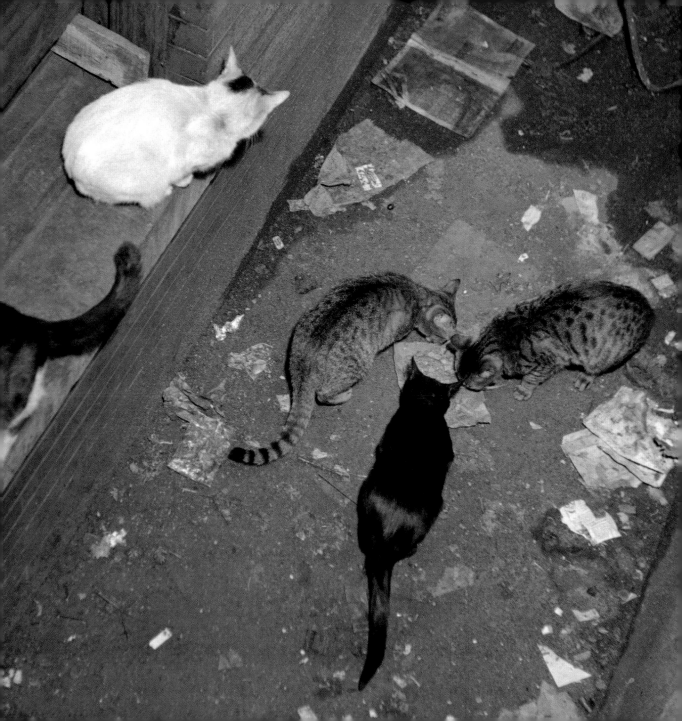

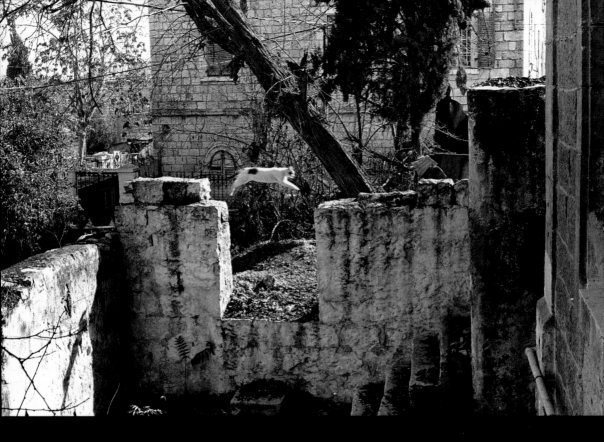

ARTHUR FREED

*Cat*

Jerusalem, Israel, 1982

"I was teaching a workshop in Jerusalem and happened
to be in this backyard. There was a cat walking along the wall,
and I realized it was going to have to jump the niche or turn around.
So I stationed myself there and waited. Luckily, it jumped.
This is my private homage, in a joking way,
to Cartier-Bresson's 'Puddle Jumper.'"

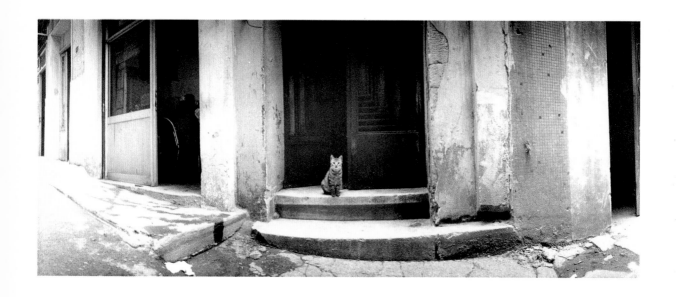

LIZZIE HIMMEL
*The Turkish Cat*
Istanbul, Turkey, 1989
"He seemed very young but he also clearly owned the house:
though I played with him a lot, I couldn't get him to leave the doorway.
As usual, I was on vacation so I could take pictures of cats—
my reason, always, for going to another city."

*Opposite:*
EUGENE ATGÉT
*Coeur de Rouen*
1915

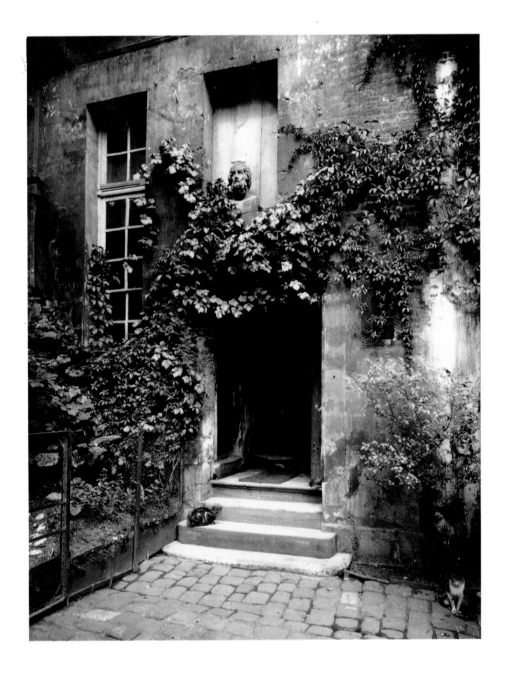

PHOTOGRAPHER UNKNOWN
*Mrs. Frederick H. Fleitman and Five of Her Siamese Cats*
Paris, 1930
The proud New York cat owner took first place
at the International Cat Club Show.

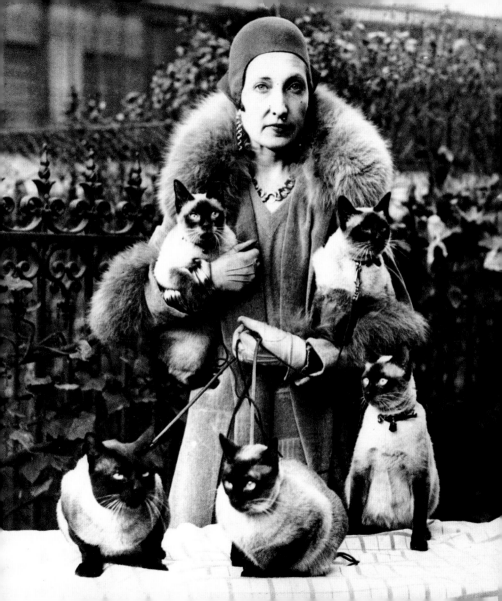

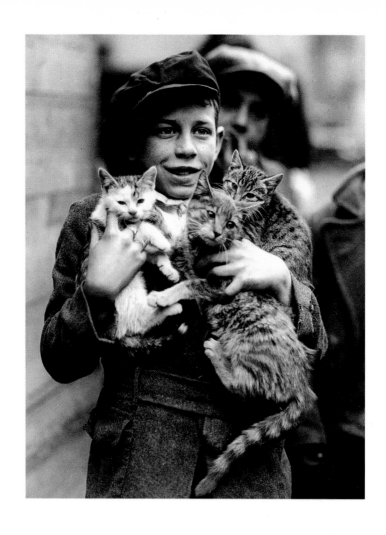

PHOTOGRAPHER UNKNOWN
*The Great Cat Round-up*
Bowling Green, New York, March 28, 1925
Jack Jagerke is the proud captor of three of the thousand-
odd stray cats that were rounded up by the Bowling Green
Neighborhood Association and then adopted as pets.

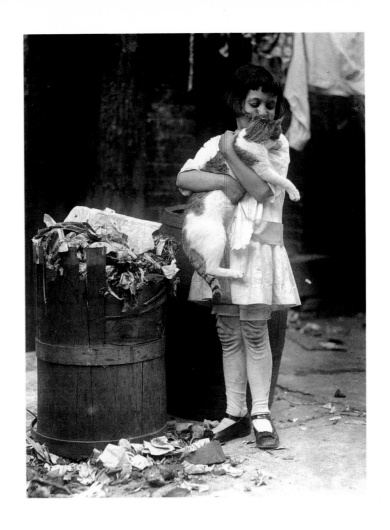

*How Infantile Paralysis is Spread*
1916
A child plays with a stray who was caught while feeding
on garbage. Such contact, it was believed in 1916,
could endanger a child's life.

WALTER CHANDOHA
*Tudor City Cat*
New York, 1970
"In those days, the East Side had a lot of character.
The cat, for instance—he was clearly from the neighborhood—
didn't budge an inch when I poked my camera in his face."

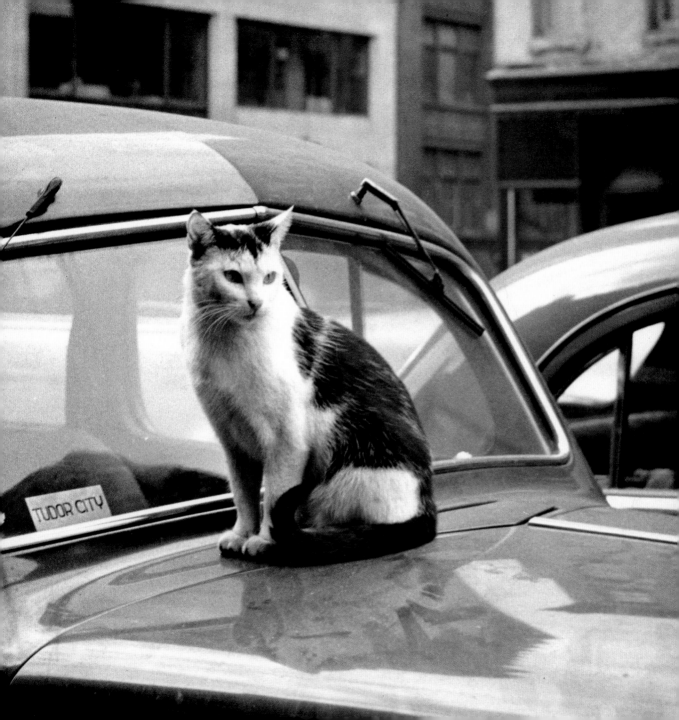

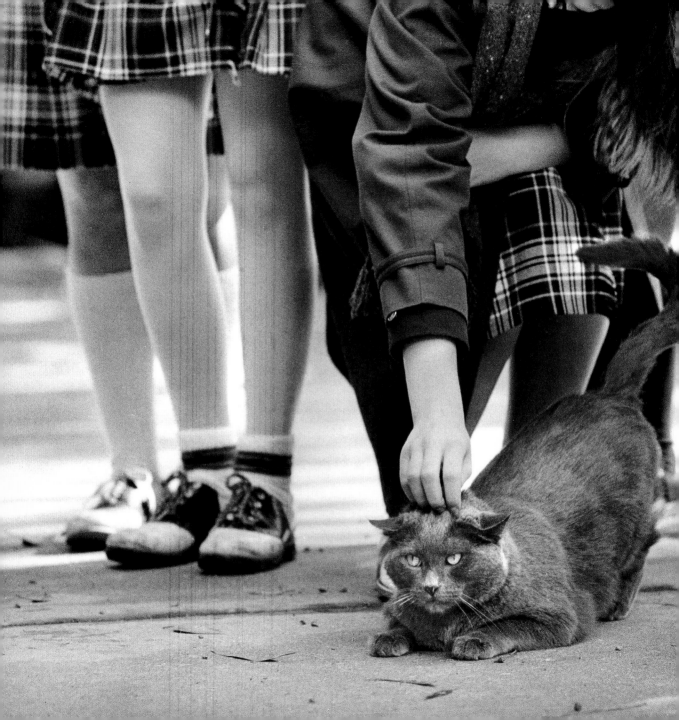

TERRY DEROY GRUBER
*Humbert Humbert,* from the *Fat Cats* Series
California, 1980
"Humbert Humbert belonged to
the Argyle Academy—an all-girls school."

36

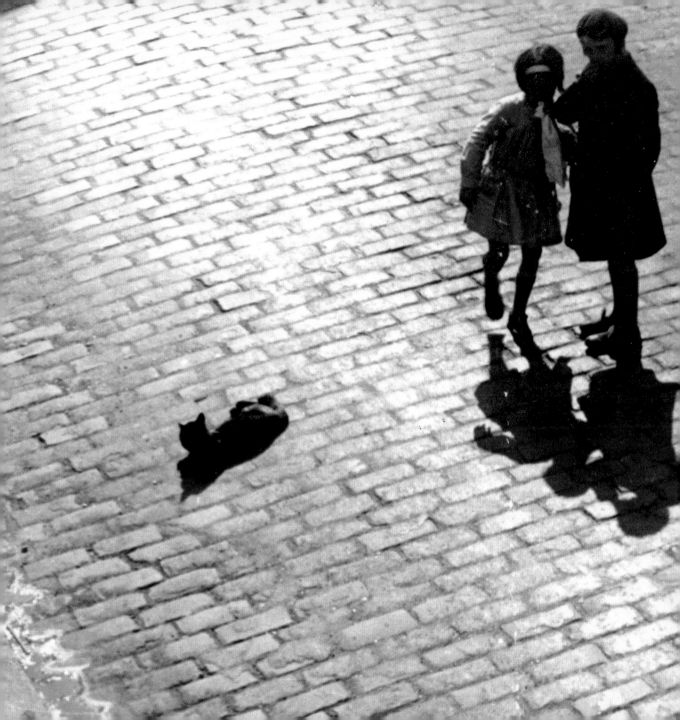

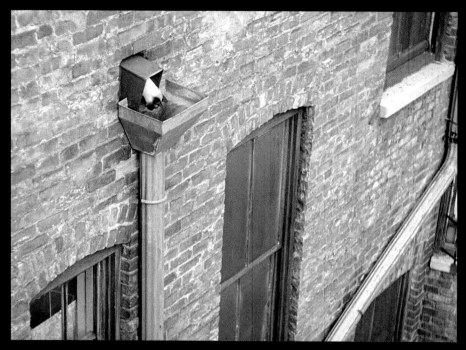

ALFRED GESCHEIDT
*Ciba*
New York, 1958
"I had two Siamese then: Columbo and Ciba, named
after a company I did a lot of work for. We'd play on the roof,
which like most of the old tenement roofs, had a lot of nooks and
crannies. I was throwing a ball when it suddenly disappeared,
and Ciba with it. My heart sank. When I got around the corner
there she was, trying to get the ball out of the drainpipe."

*Opposite:*
PHOTOGRAPHER UNKNOWN
*Animal Rescue League*
1940

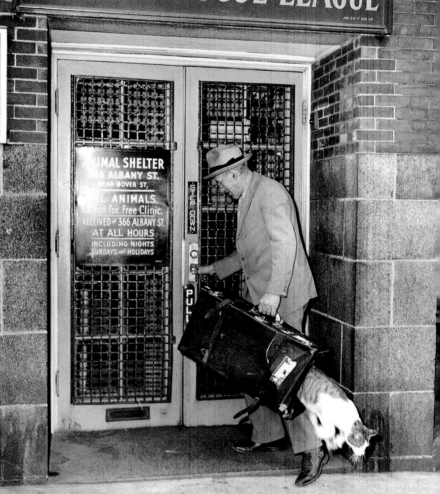

Kritina Lee Knief
*Captain, Spaghetti and Cat*
Venice, 1992

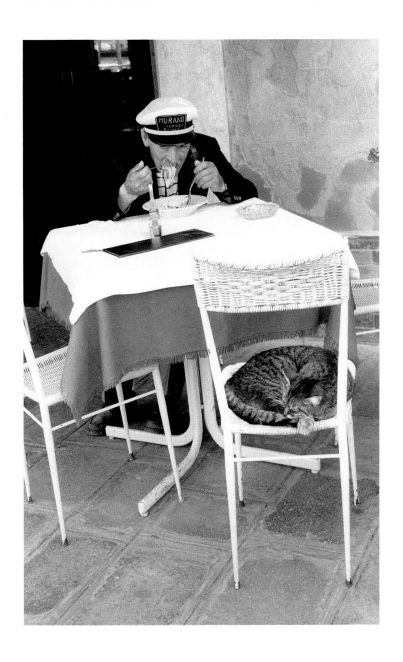

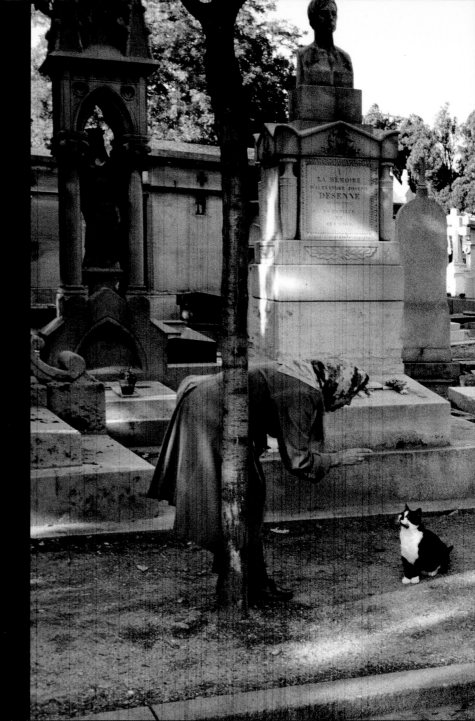

Marvin W. Schwartz
*Montparnasse Cemetery*
Paris, 1980

"I'd planned that day to take pictures
of cats, and I went up to the cemetery
with my tripod. The gendarme told me
I couldn't bring it in—you can't bring
tripods all over the place in Paris.
So I asked him if there were any cats
around. He was baffled. He asked
me why. 'You know,' I said,
'un petit animal?' and I meowed.
He wanted to know what for.
'It's my life,' I said dramatically,
hitting my heart for emphasis,
'it's my love.' That convinced him.
He told me there were some women
who met at noon everyday at the
large monument to feed the cats.
'Hurry,' he said, 'so you catch them!'"

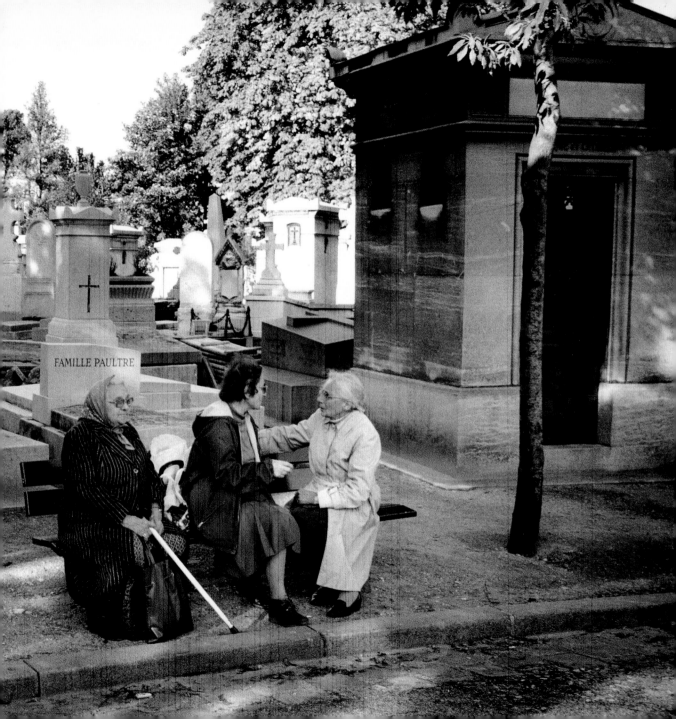

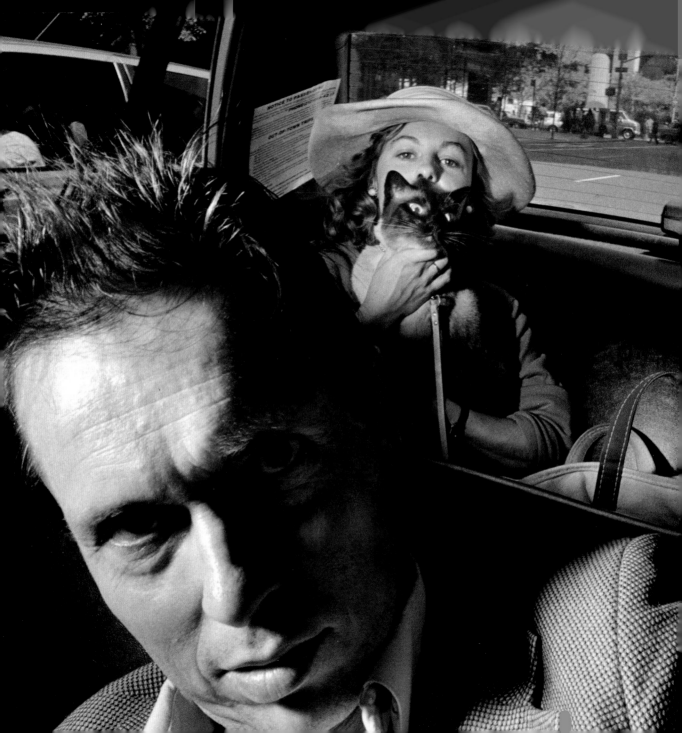

RYAN WEIDEMAN
*Self-Portrait with Woman and Cat*
New York, 1987
"This was very spontaneous.
I talk to whoever gets into my cab,
and if they're willing, I make a picture.
Taxi drivers don't have to stop for a customer
with an animal, but this cat was cool.
He seemed to be the woman's bodyguard."

JOYCE RAVID
*Batty Ravid, chat de luxe*
New York, 1980

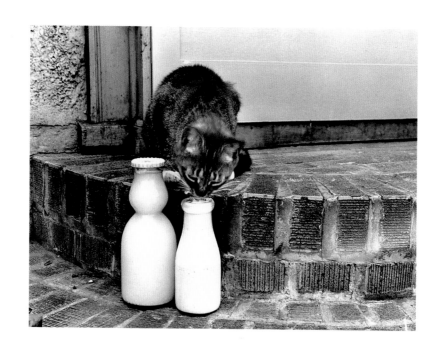

PHOTOGRAPHER UNKNOWN
*Cat Drinks Milk from a Bottle*
New York, 1933

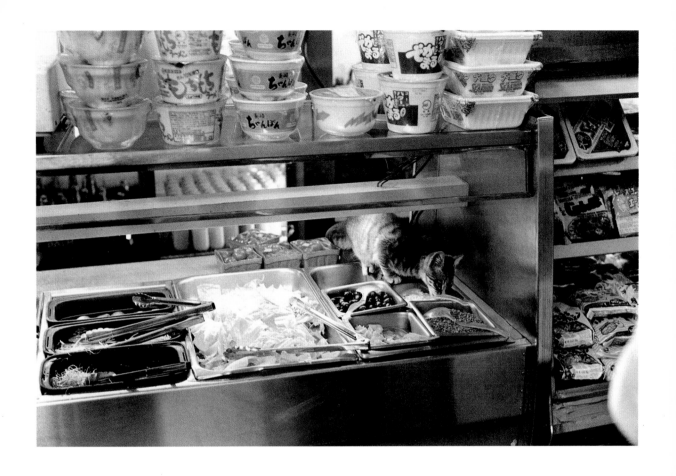

DEREK BERG
*Untitled*
New York, 1991

PHOTOGRAPHER UNKNOWN
*Desiree Sampson and Her Cat Billy*
London, 1950

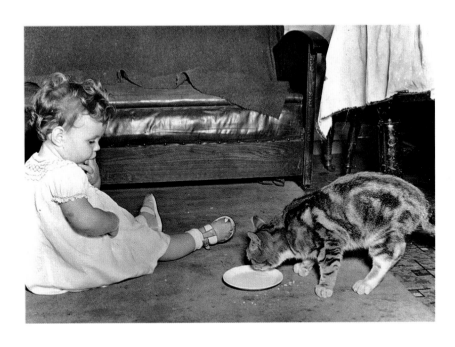

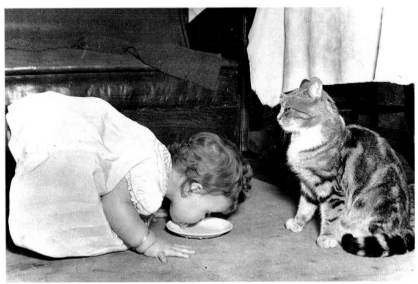

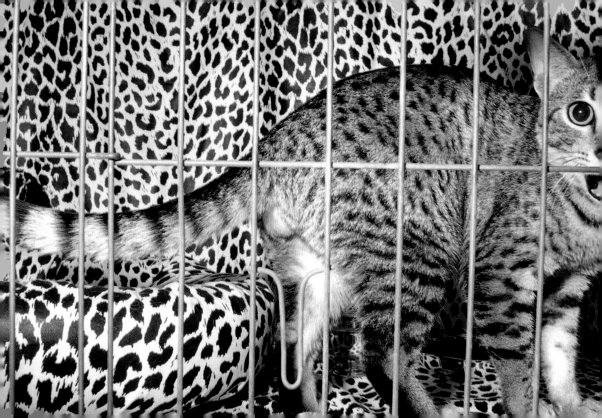

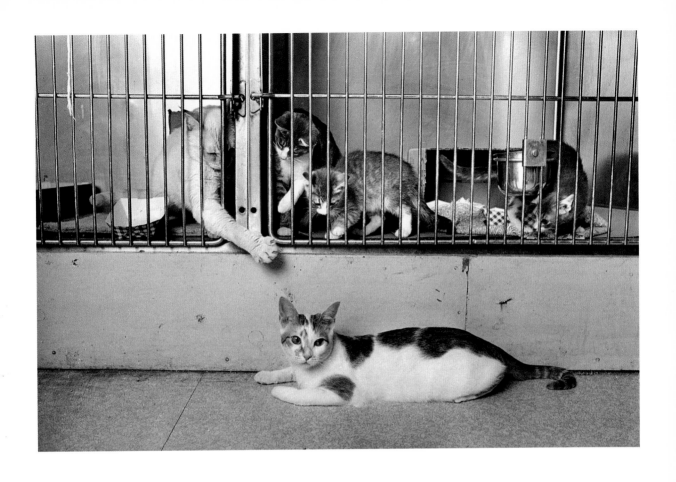

TERRY deROY GRUBER
*Houdini*, from the *Working Cats* Series
New York, 1979
"During his month-long stay at the Humane Society,
this cat became one of the shelter's favorites. They named him
Houdini. 'They've yet to build a cage to hold him,' the staff said,
'and the other cats get extremely jealous.'"

PHOTOGRAPHER UNKNOWN
*Fire Department Mascot*
New York, 1941

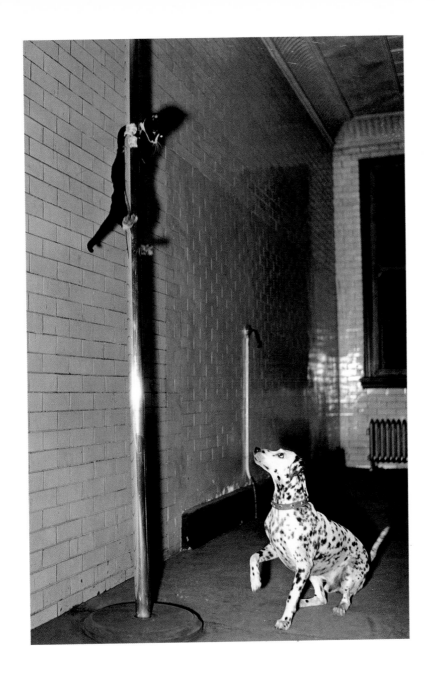

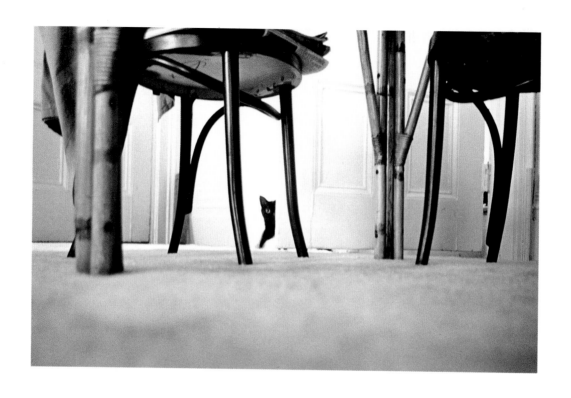

LINDA RASKIN
*Sheba, New York City #1* and
*Sheba, New York City #2*
1993
"For what seemed like ten long minutes I lay in wait, hoping
Sheba, who's half-Siamese, would emerge from the doorway.
But I was unprepared for the way she made her entrance, like
some tiny woodland creature amid a forest of chair and table legs.
Some time later, while I was making a formal, white-on-white
study of bathtub and shower curtain, she quietly snuck in."

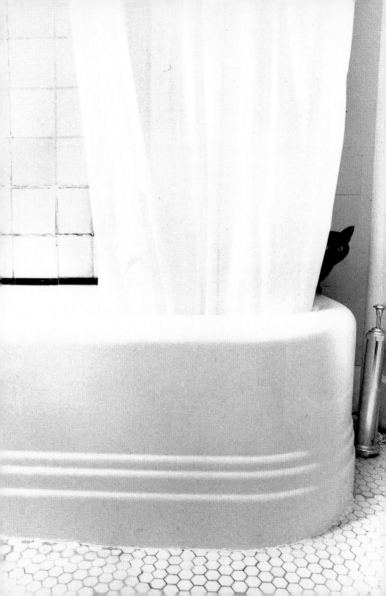

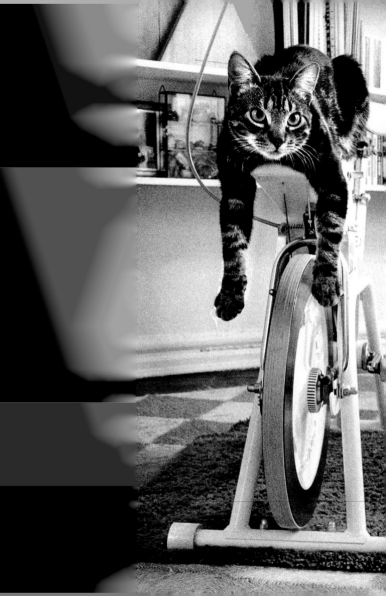

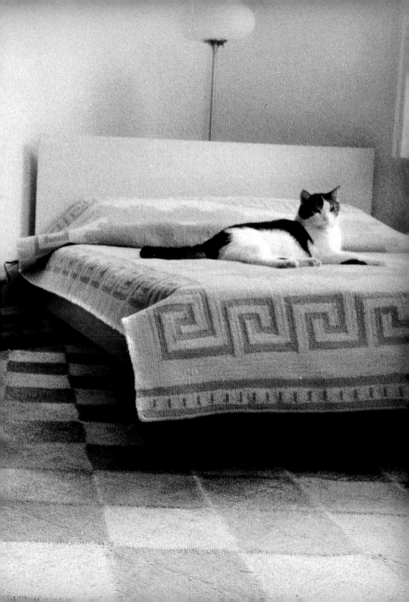

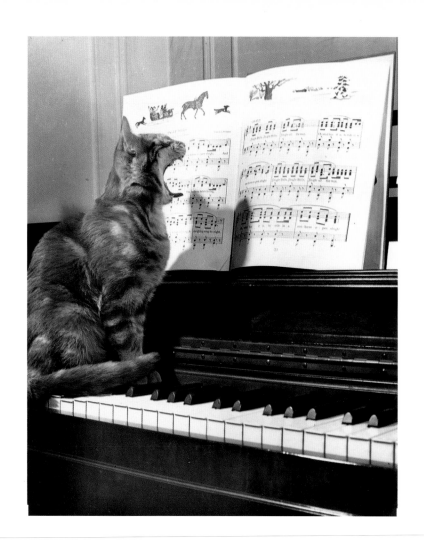

GEORGE W. GRAY
*Singing Cat*
New York, 1946
Rusty, the photographer's 6-month-old kitten,
rehearses a Christmas "Catenza."

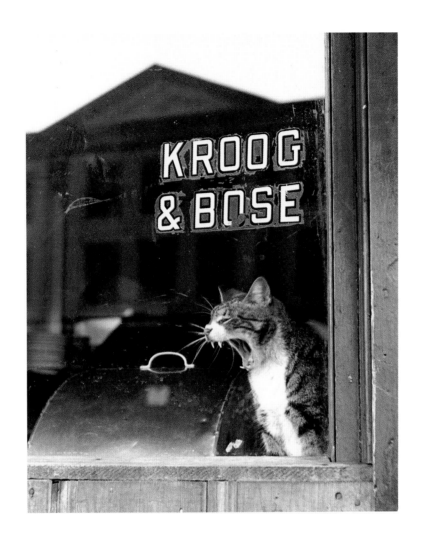

WALTER CHANDOHA
*Guard Cat*
New York, 1955
At the Fulton Fish Market, a store's cat keeps
a watchful eye on the street.

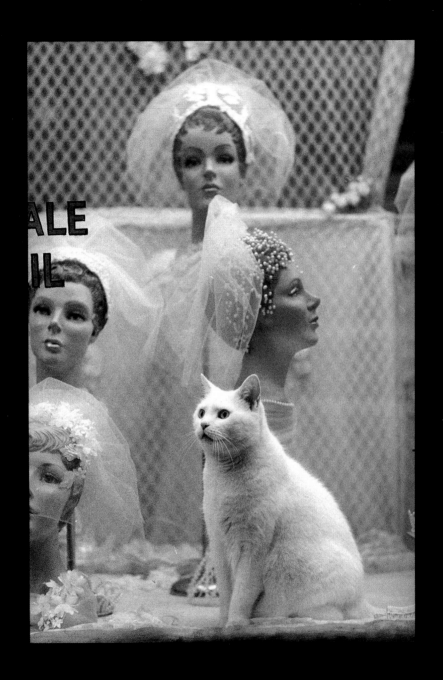

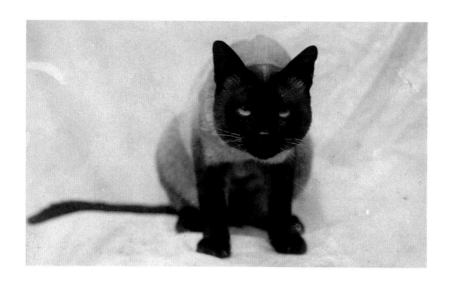

Jessie Tarbox Beals
*Siamese Cat*
c. 1905

*Opposite:*
Ylla
*Face-off with Tabby*
New York, c. 1950
A silent confrontation with a leader of what the
photographer called the "Feline Underworld."

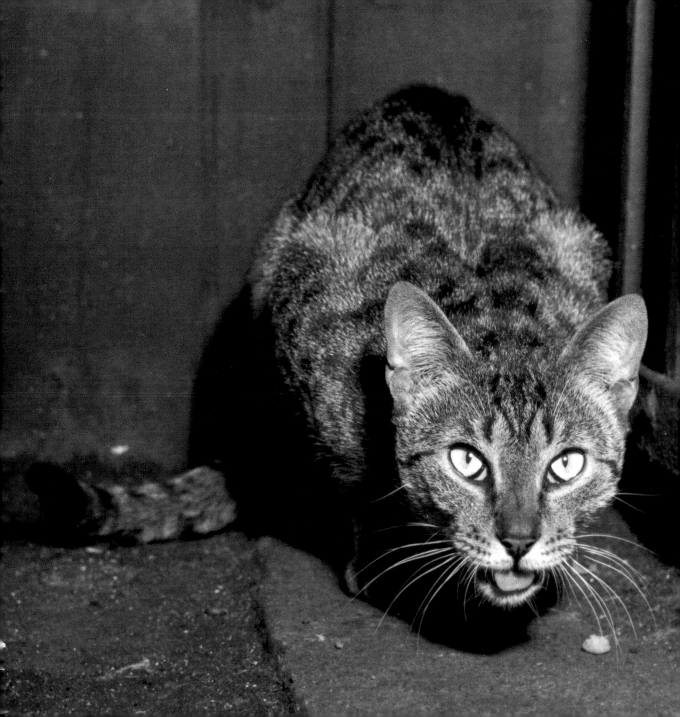

DEREK BERG
*Untitled*
Seaside, Oregon, 1991

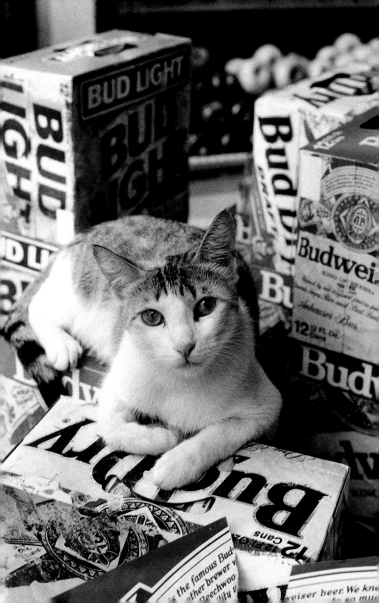

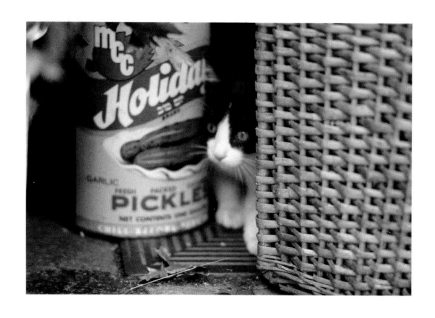

TERRY deROY GRUBER
*Shy Cat*
New York, 1979

*Opposite:*
PETER HUJAR
*Cat on a Cash Register*
New York, 1970

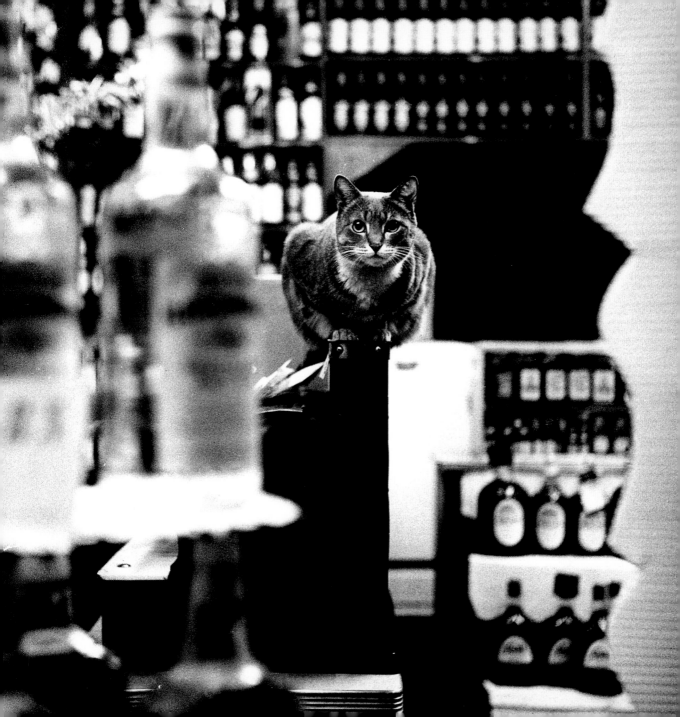

TERRY deROY GRUBER
*Morris II*, from the *Fat Cats* Series
New York, 1980
"At the press conference at Sardi's Restaurant for his book
*The Morris Approach*, Morris II was placed on the table with
his co-author at his right so they could both sign copies.
Later he went to the podium to give a speech, and they had
the voice of Morris talking. 'One thing for you beginners
to remember,' Morris said. 'Never seem too eager.'"

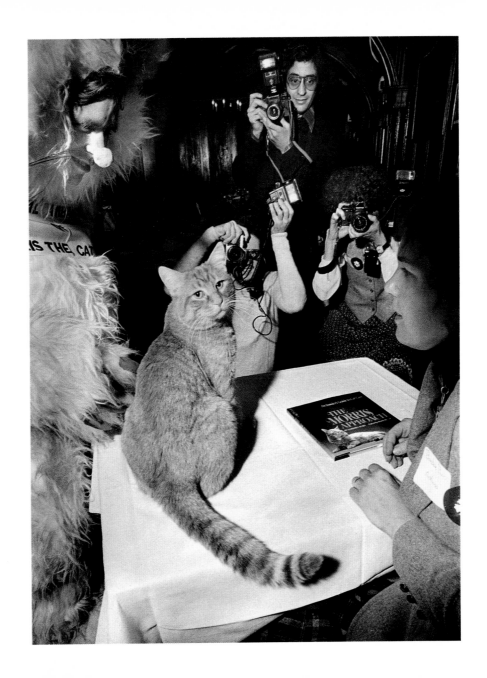

KIRBY MCELHEARN
*Untitled*
New York, 1982
Firefighter Charles Martoni uses his own air supply
to save the life of a cat during a three-alarm blaze.

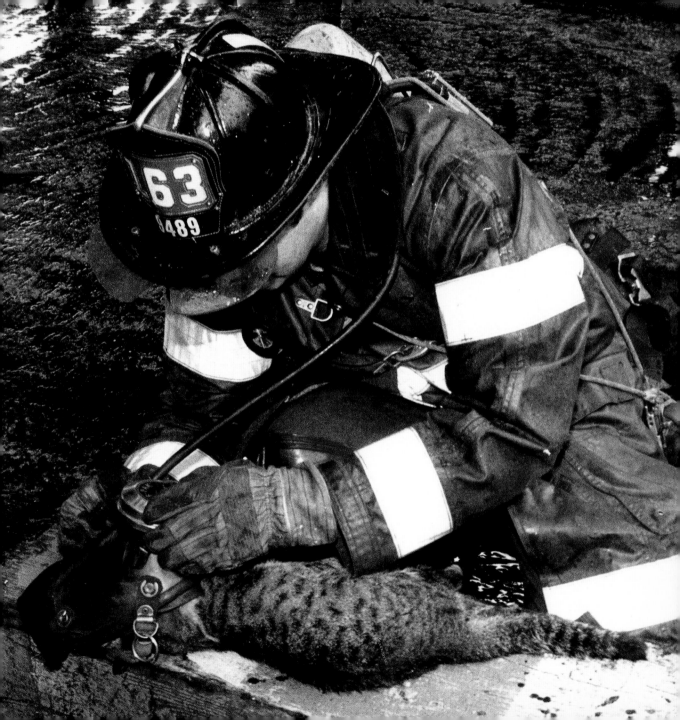

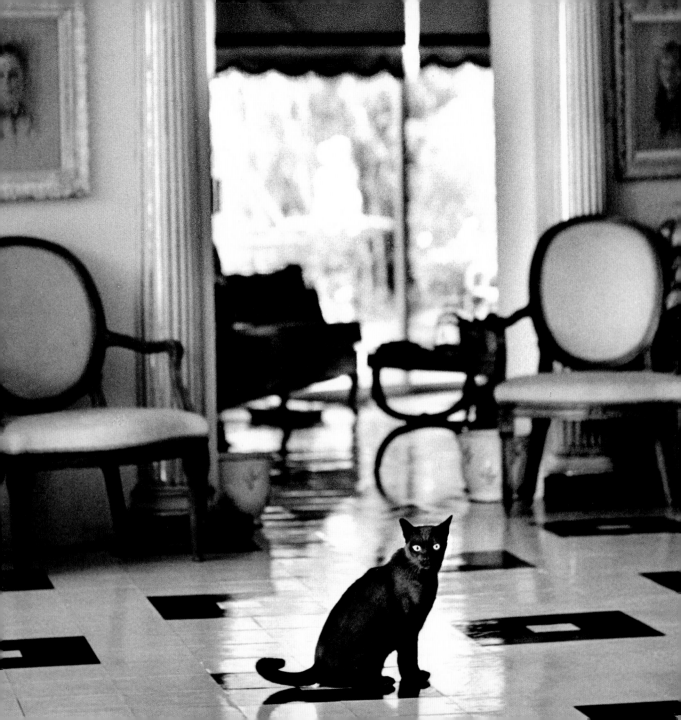

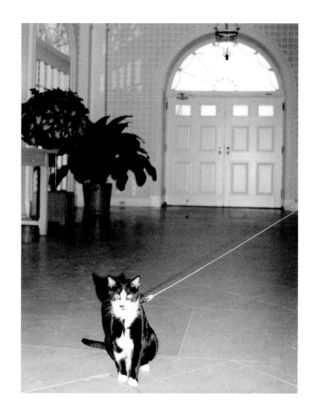

*Opposite:*
TERRY deROY GRUBER
*Topaz,* from the *Fat Cats* Series
Palm Springs, 1980
As Topaz explained, "On my left you'll notice a King Edward
settee given to Mrs. Moore by the Prince of Wales. Behind that
is my own nineteenth century Regency litterbox."

PAUL J. RICHARDS
*Socks Clinton*
Washington, D.C., March 9, 1993
At home in sophisticated surroundings, the First Family's
cat poses in the Palm Room of the White House.

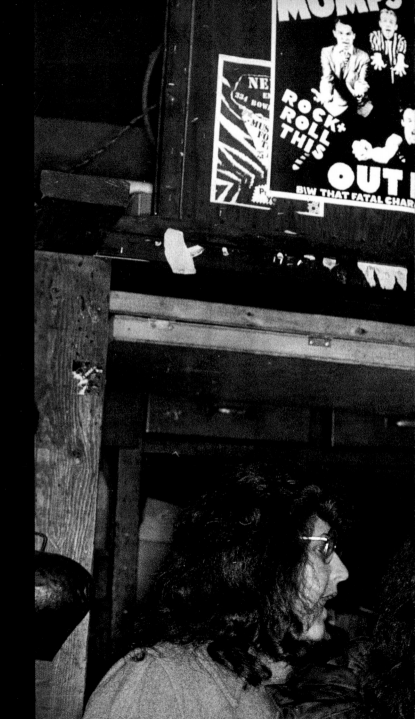

Terry deRoy Gruber
*Fluffy*, from the *Working Cats* Series
New York, 1979
"Fluffy had a little niche inside CBGB's so that he
could hang out and be above it all.
The rocker looking up said, 'The cat and I have
been friends a long time. We know things
nobody else knows, like who runs the planet,
and where the aliens are landing—.'"

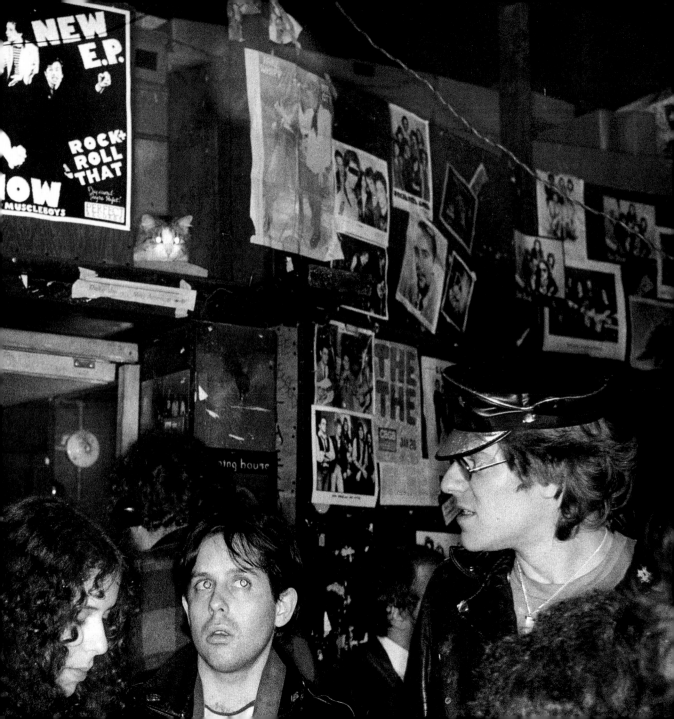

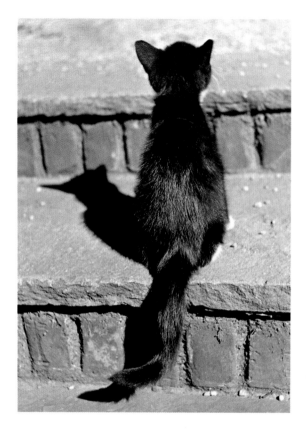

YLLA
*Kitten from Behind*
New York, c. 1951

# CREDITS

Design: J. C. Suarès
Picture Editor: Peter C. Jones
Text Editor & Captions: Jane R. Martin
Assistant Picture Editor: Lisa MacDonald

# SOURCES